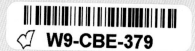
For all the men who are learning to be dads, and in memory of my dad.

Sheila M. Kelly, Ed.D. *(as a teenager, with her father)* is a child clinical psychologist in private practice who specializes in working with preschool and primary-age children. A native of Canada, she has lived and worked in Western Massachusetts and currently resides in Saskatchewan, Canada. She has three children and two grandchildren.

For my dad with love.

Shelley Rotner *(as a child, with her father)* is the creator of numerous highly praised photo books for children, including *Lots of Moms,* also coauthored by Sheila M. Kelly. She lives with her husband and daughter in Northampton, Massachusetts.

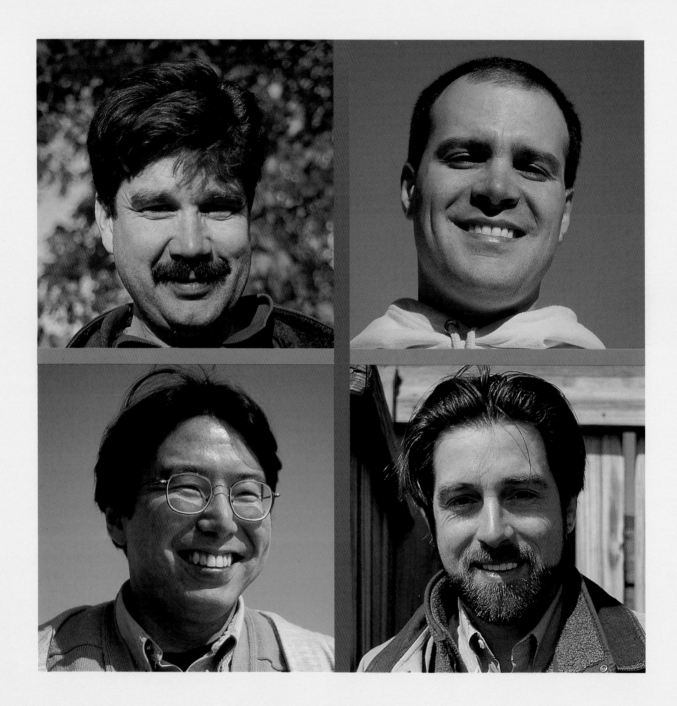

LOTS OF DADS

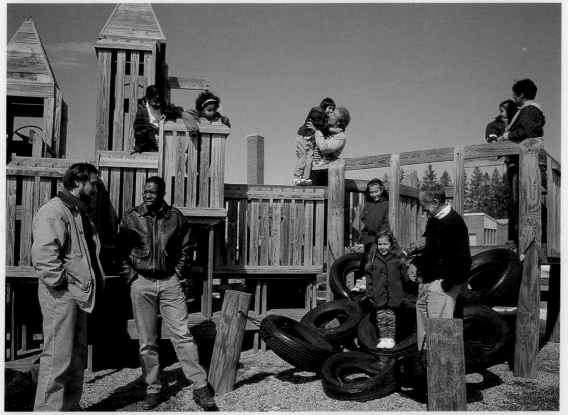

SHELLEY ROTNER & SHEILA M. KELLY
PHOTOGRAPHS BY SHELLEY ROTNER

Dial Books for Young Readers New York

Published by Dial Books for Young Readers
A Division of Penguin Books USA Inc.
375 Hudson Street
New York, New York 10014

Designed by Hans Teensma / Impress, Inc.

Printed in Hong Kong

First Edition
1 3 5 7 9 10 8 6 4 2

Library of Congress Cataloging in Publication Data
Rotner, Shelley.
Lots of dads/ Shelley Rotner and Sheila M. Kelly;
photographs by Shelley Rotner.
p. cm.
ISBN 0-8037-2086-6.—ISBN 0-8037-2089-0
1. Fathers—Pictorial works—Juvenile literature. I. Kelly, Sheila M. II. Title.
HQ756.R68 1997
306.874'2—dc20 96-33714 CIP AC

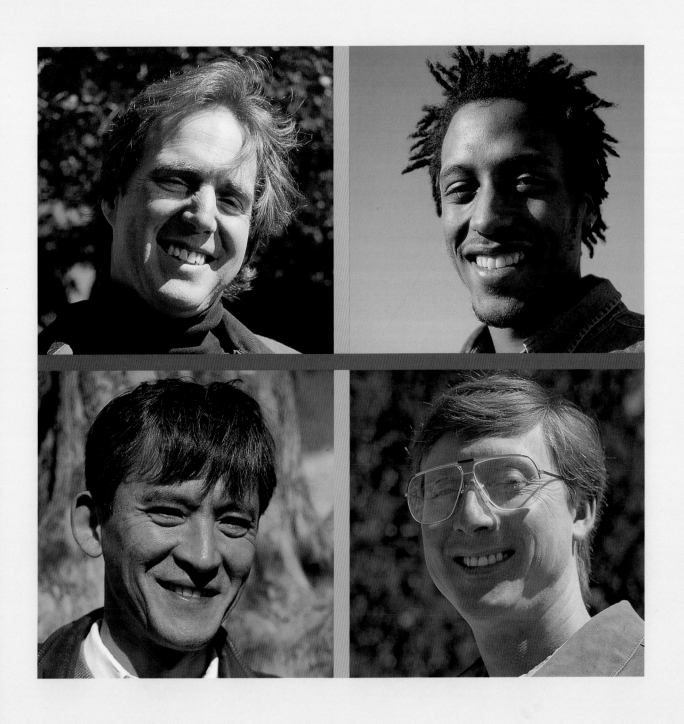

There are lots of dads.

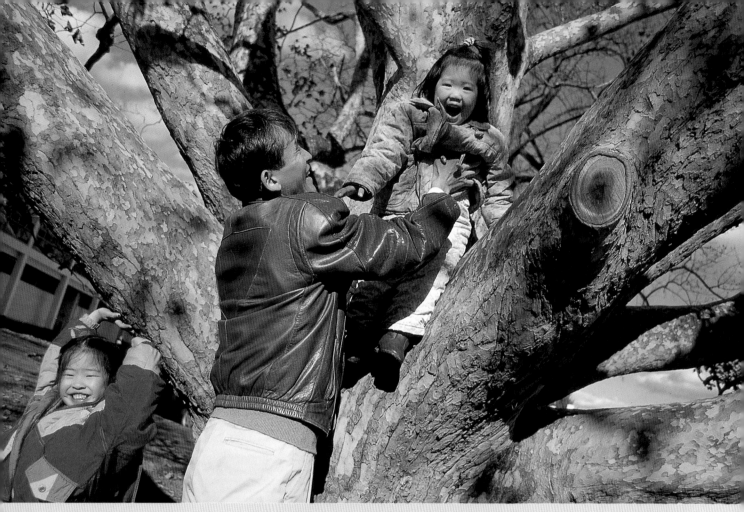

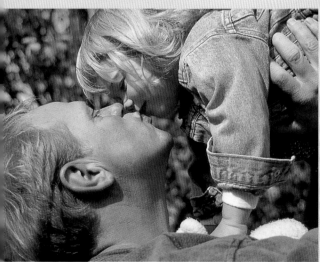

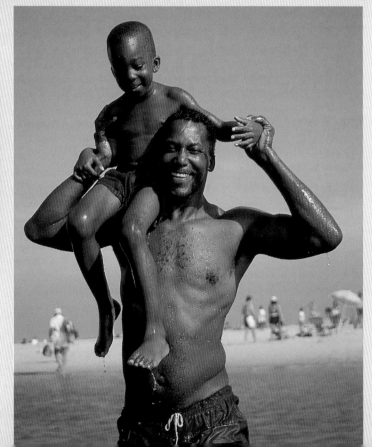

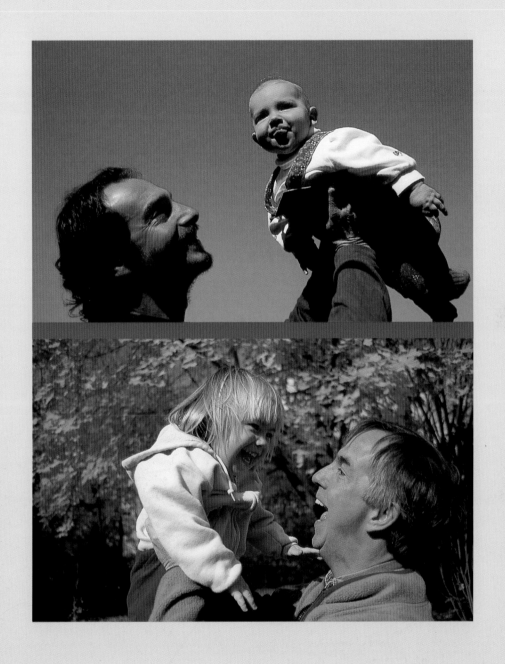

They're big and can lift you high.

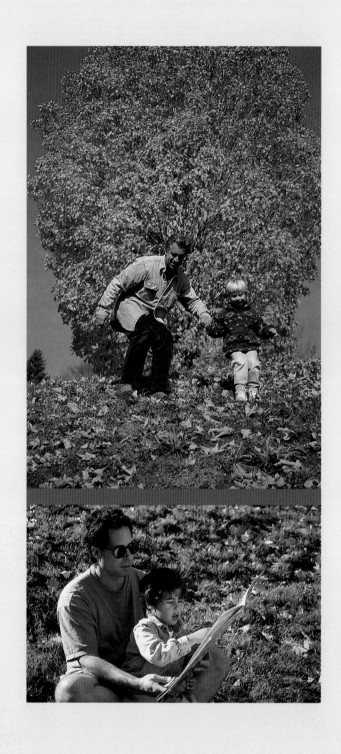

They help you when you need it,

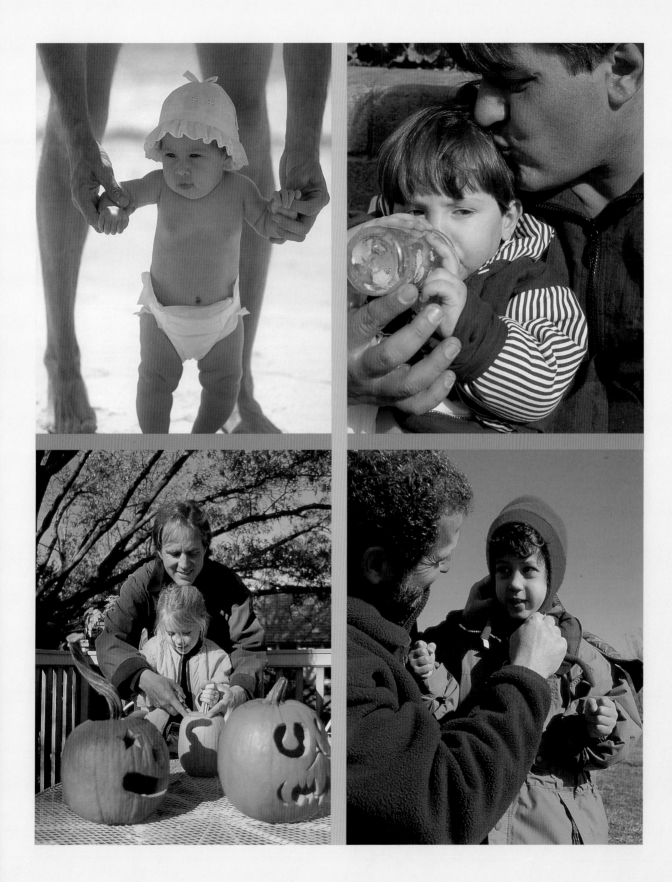

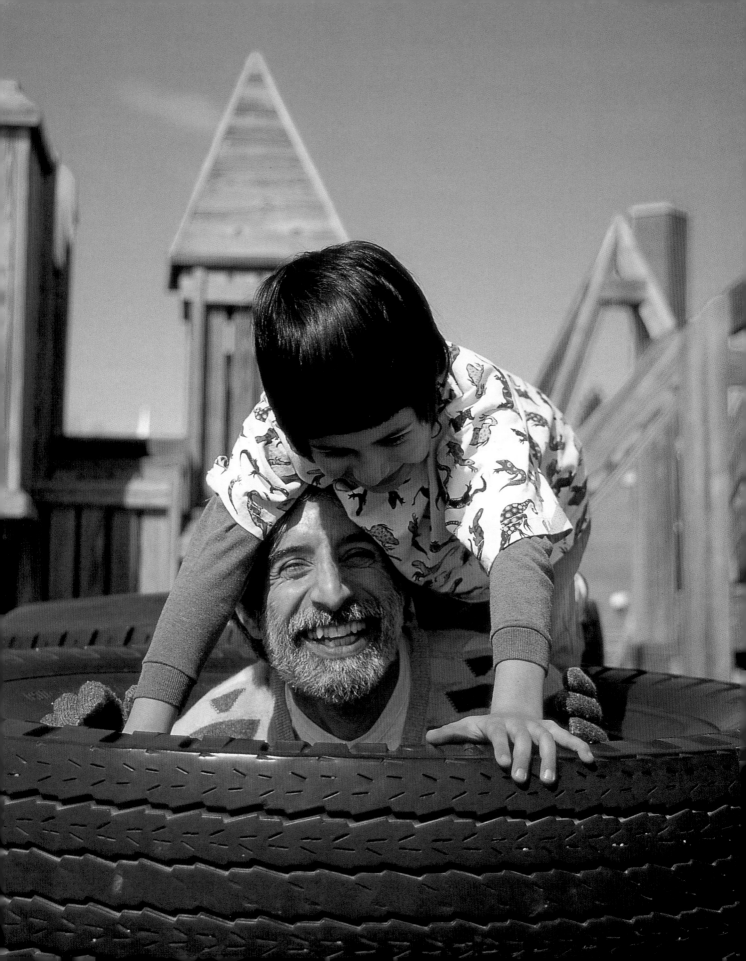

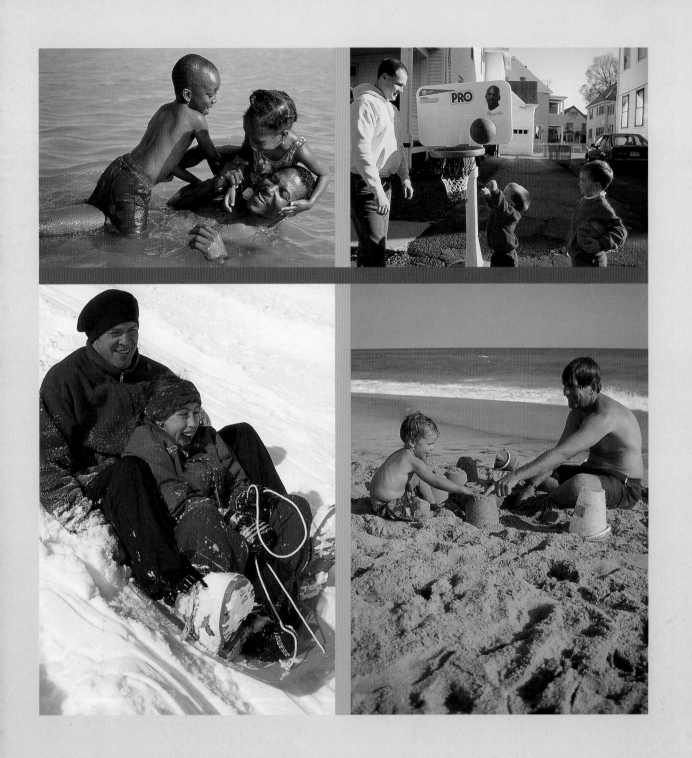

and they like to play with you.

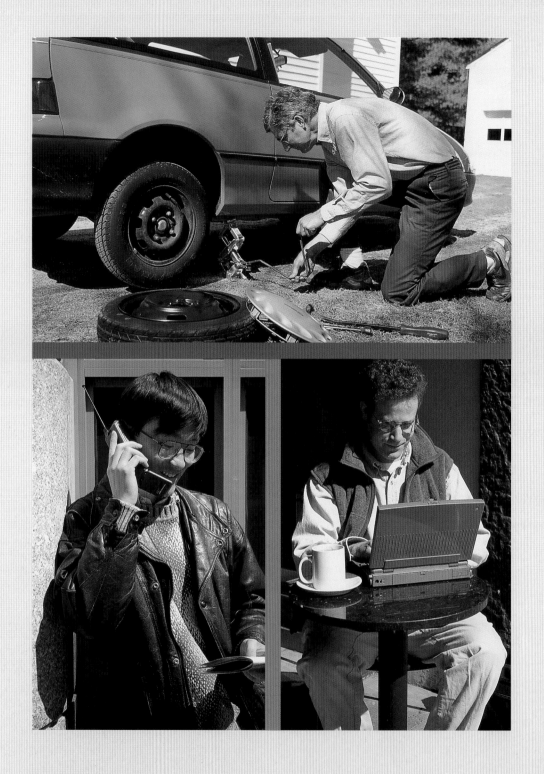

Sometimes they're busy, or say, "Not now!"

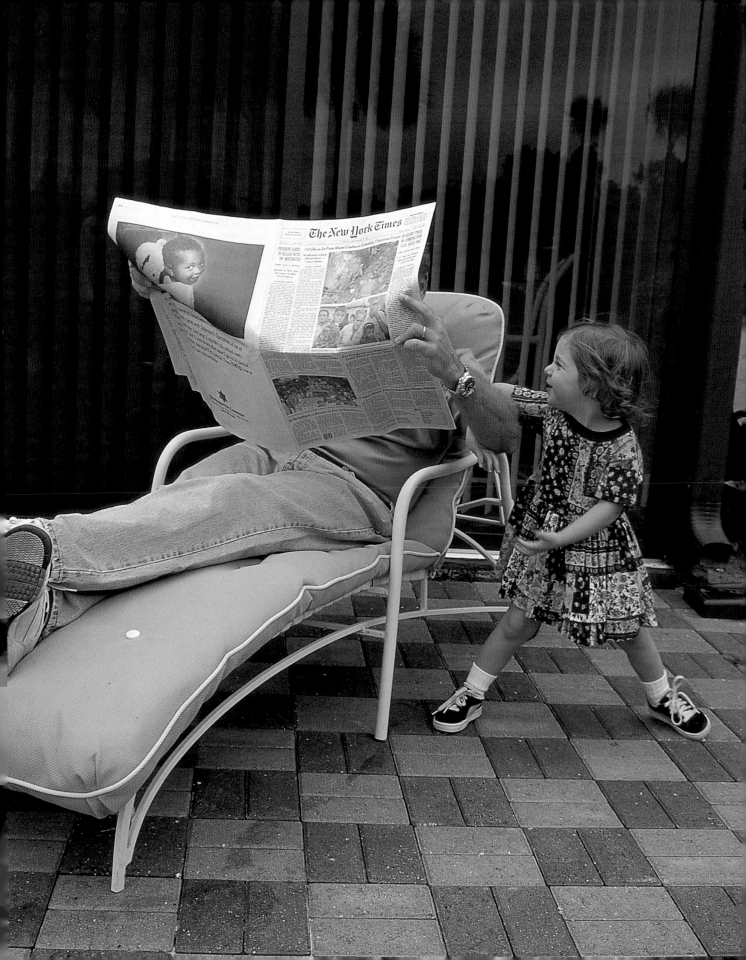

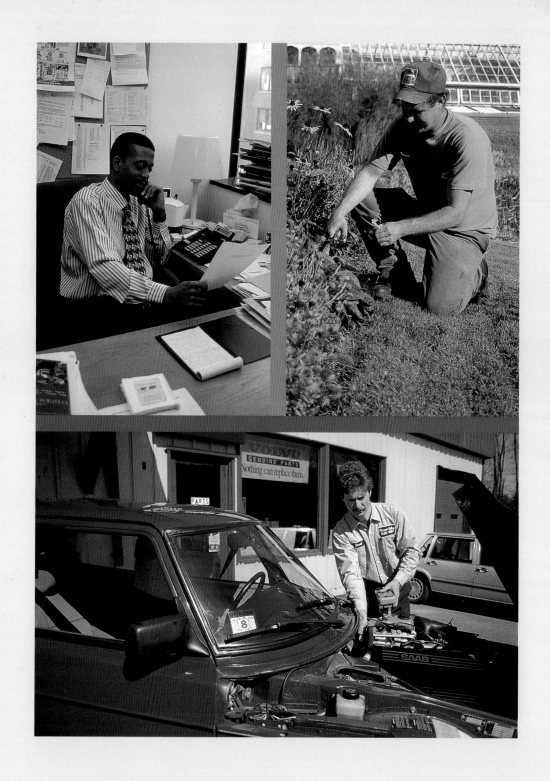

Most days dads have to work.

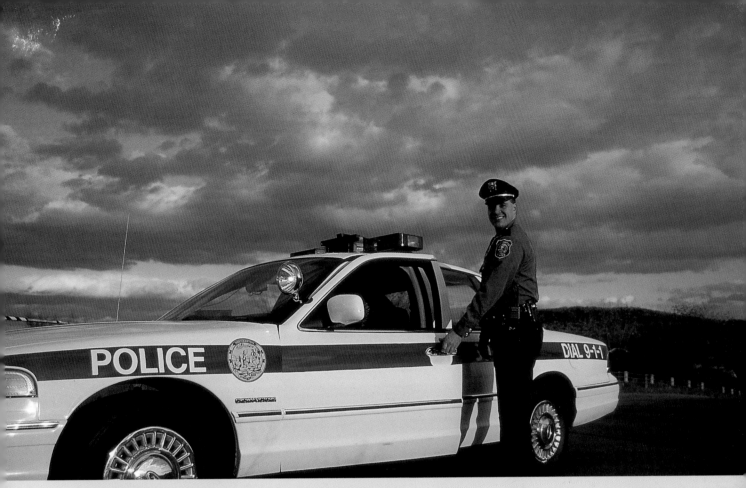

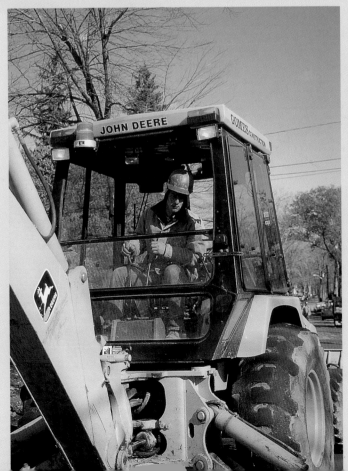

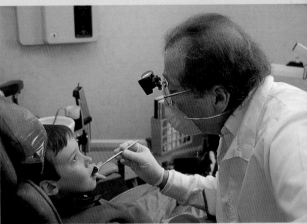

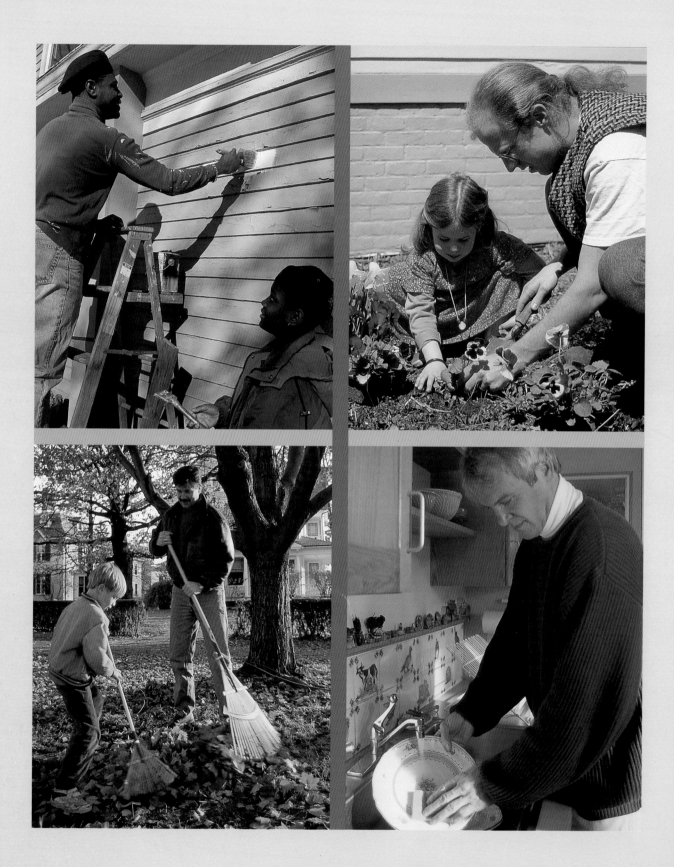

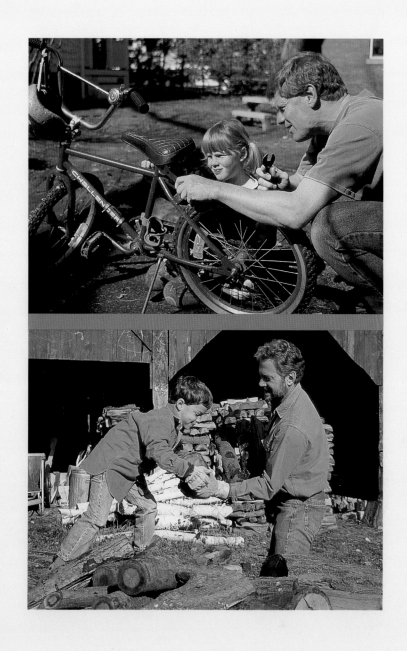

Sometimes they fix things
and do chores around the house.

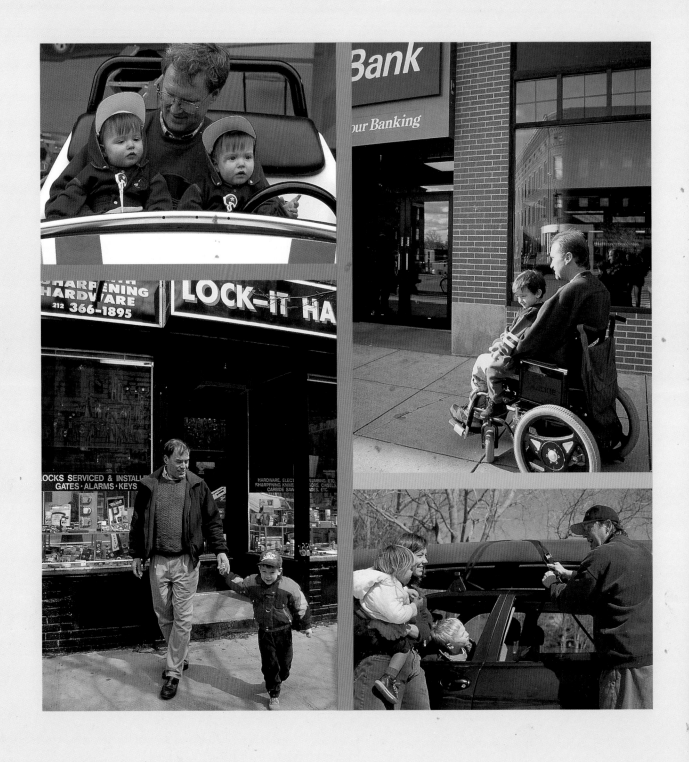

Other times they take you on errands or on a trip.

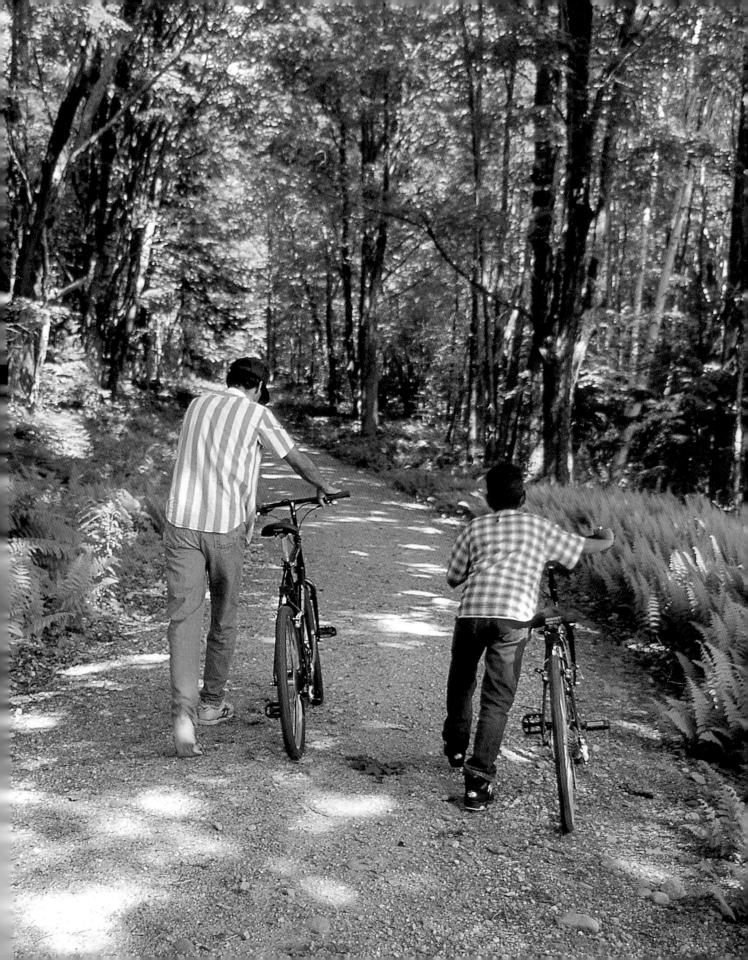

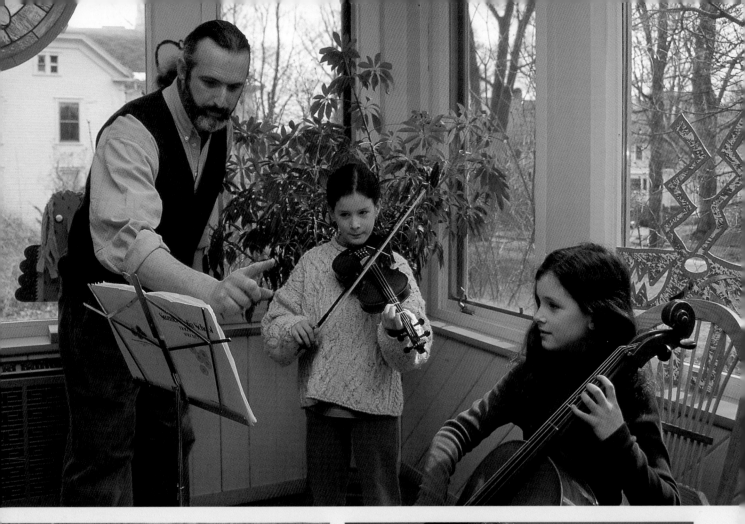

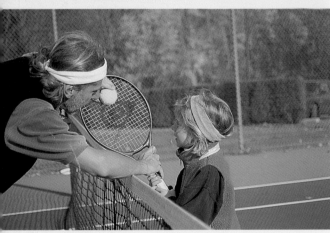

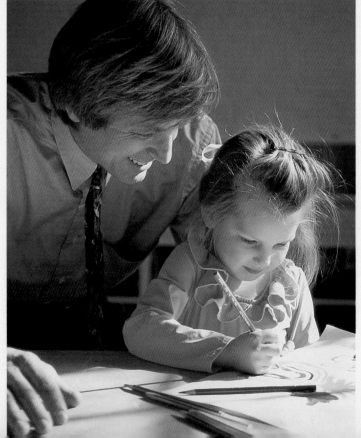

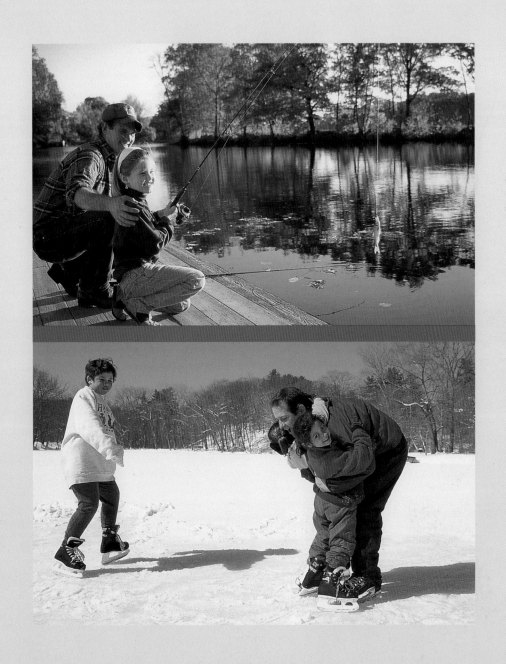

Dads like to show you how to do things
and are proud of what you can do.

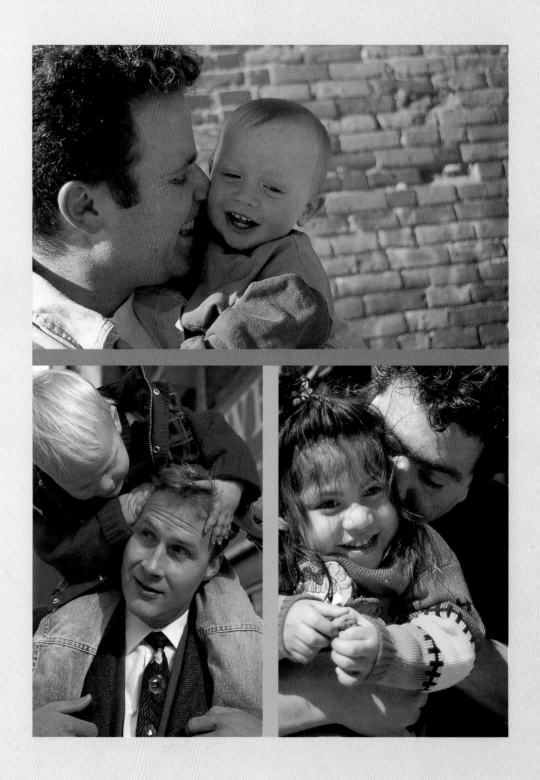

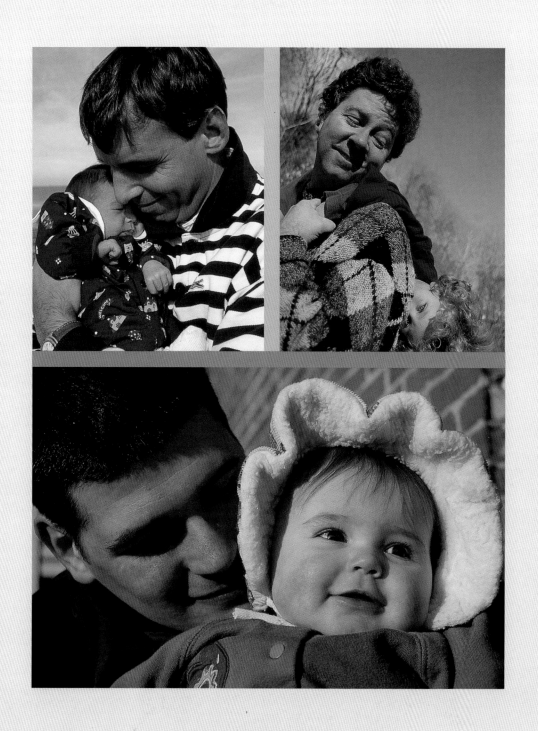

They really love you.

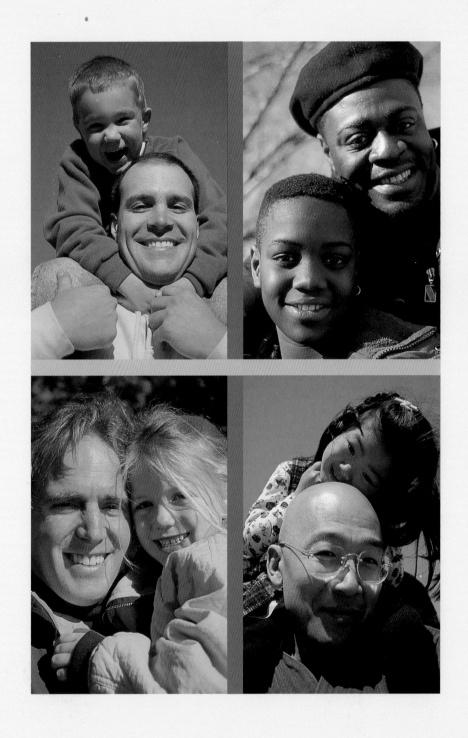

It's good there are lots of dads.